How to Cut Drawings on SCRATCHBOARD

How to Cut Drawings on SCRATCHBOARD

by Merritt Cutler

WATSON-GUPTILL PUBLICATIONS,

New York, New York

Copyright © 1960 by Watson-Guptill Publications

First published 1949 in New York by Watson-Guptill Publications,
a division of Billboard Publications Inc.,
1515 Broadway, New York, N.Y. 10036

Library of Congress Catalog Card Number: 59-15674
ISBN 0-8230-2350-8

Manufactured in U.S.A.

First Edition
 First Printing, 1949
Second Edition
 First Printing, 1960
 Second Printing, 1965
 Third Printing, 1968
 Fourth Printing, 1971
 Fifth Printing, 1977

PUBLISHER'S NOTE

AMONG THE THOUSANDS OF BLACK-AND-WHITE DRAWINGS which artists make each year for reproduction on the editorial and advertising pages of all sorts of publications, an ever-increasing number are done on the unique, chalk-coated material known as scratchboard. It is therefore somewhat surprising that so little has been written to acquaint the artist, and the would-be artist, with this versatile and intriguing material.

It is the purpose of this book to supply this lack, at least in part, by demonstrating with a down-to-earth and generously illustrated text precisely how the artist produces the customary types of scratchboard work.

We can think of no person better qualified for this task than Merritt Cutler, who is the author of this volume and an outstanding artist whose notable work in the scratchboard medium has long embellished the pages of leading publications. A superb technician himself, he also possesses both the ability and the willingness to explain every detail of scratchboard procedure.

Starting with a description of the chalk-coated board which gives scratchboard art its name and with a discussion of the choice and preparation of the tools which he has found best adapted to his meticulous manner of working, the author demonstrates through ample text, photographs and drawings, each essential move: the selecting of subject matter, the making of preliminary studies, the transferring to final board, the inking, and, most important of all, the cutting. Methods of correction are also introduced. Inasmuch as most scratchboard drawings are done with reproduction in mind, he touches upon this subject too, as well as upon photography as it relates to the scratchboard artist's requirements. And because much of today's scratchboard work suggests in appearance the woodcut and wood engraving (in fact these mediums are often deliberately imitated on scratchboard in order to meet a strong demand among editors, advertising agencies, and others), Mr. Cutler draws comparisons between such mediums and scratchboard. Professional tips and words of sound advice round out the whole.

Pictures are, of course, the heart of such a book. The many selections which the author has included are beautifully reproduced; they vary greatly in subject matter, composition, and technical handling. Each is used to exemplify some particular point brought out by the text.

In short, here is a book which in every respect lives up to the Watson-Guptill tradition of providing the best of self-help material prepared by leaders in many branches of fine and commercial art. It is hoped that the book will inspire the reader to go even beyond the methods presented, for the art of scratchboard, being relatively young, offers opportunities as yet unexplored. Given a background of technical mastery, such as the reader should be able to acquire through the application of the well-organized lessons of this book, there seems almost no limit to what he can eventually hope to do in the way of developing new, distinctive, and highly individual scratchboard styles.

CONTENTS

INTRODUCTION

THIS IS NOT A BOOK ON ART, BUT RATHER A MANUAL on how to make the best use of a comparatively new art medium, scratchboard. I have tried to hold to the fundamentals learned through my twenty-five years' work in this exciting medium.

The effects to be obtained with scratchboard are tremendously varied and, as with all other mediums, reflect both the artist's creative imagination and his technical command. Scratchboard is a line medium, that is, pure black-and-white; so a finished scratchboard drawing closely resembles a woodcut or a steel engraving. But, while both of these are *prints* and must first be cut on wood or steel and then inked and printed, a scratchboard drawing is just as truly a *drawing* as any pen or brush rendering. However, instead of drawing *black* lines on *white,* the scratchboard artist creates *white* lines on *black.*

Although we are generally unaccustomed to approaching pictures from dark to light, I have been very impressed by the number of children and beginners who have told me that they felt much more confidence and control when working with this medium, and even after twenty-five years' professional experience, I still get a thrill as I work that goes beyond all explanation when I see each new revelation of white on black.

Chapter 1

DESCRIPTION AND PREPARATION OF THE MATERIAL

COMPARED WITH OIL PAINTING, crayon, watercolor, or pen and ink, scratchboard is a new medium. All these others require putting a dark line or tone on a white surface. A scratchboard drawing, however, is created by cutting through a black coating, placed upon the surface of a special chalk-coated board, to reveal the white underbody, giving an effect like that seen in Fig. 1.

Scratchboard can be bought in most good art supply stores. Be sure, when you order it, that you get only the *smooth-surface* type. There are also on the market a scratchboard made in England (where it is called scraperboard) and one made in Austria. Other types of chalk-coated boards come in textured or stippled surfaces, but these are made for other purposes.

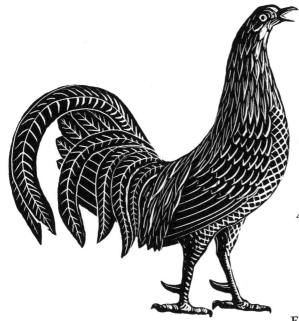

A simple scratchboard drawing

FIGURE 1

FIGURE 2

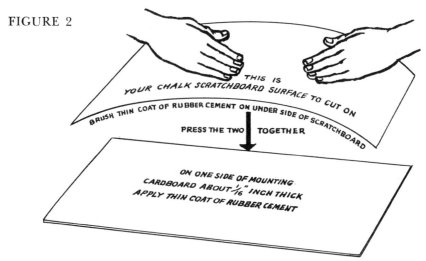

THIS IS
YOUR CHALK SCRATCHBOARD SURFACE TO CUT ON

BRUSH THIN COAT OF RUBBER CEMENT ON UNDER SIDE OF SCRATCHBOARD

PRESS THE TWO TOGETHER

ON ONE SIDE OF MOUNTING
CARDBOARD ABOUT 1/16" INCH THICK
APPLY THIN COAT OF RUBBER CEMENT

How scratchboard is mounted

Scratchboard comes in 22 x 28 inch, chalk-surfaced sheets and has a tendency to curl or buckle rather than lie flat. So, unless only very small pieces are to be used, it is best to mount the scratchboard on another piece of cardboard (Fig. 2). Be sure that the scratchboard is mounted with the chalk-surface up. This is whiter and smoother than the other side. Rather than mounting the entire sheet and then cutting to size, I usually mount a piece the size I wish to use. Mounting the chalkboard not only makes it lie flat, it also protects it from cracking, for the chalk surface, if bent, cracks quite easily.

Moisture, even humidity in the air, affects the chalk surface adversely, making it cut badly. When the atmosphere is very humid, it is sometimes wise to warm or dry the board just before using it to insure clean, crisp cutting.

The first step in making a scratchboard drawing is the application of a thin coat of black waterproof ink to the hard, smooth, white surface of the board (Fig. 3). If you have your design clearly in mind, you will naturally not apply the black ink to any considerable areas that are to remain white in the finished drawing.

Applying the ink

FIGURE 3

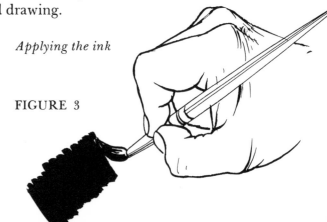

Chapter **2**

THE TOOLS

AS FAR AS I KNOW, ART STORES OFFER only a few tools made expressly for scratchboard cutting, presumably because any sharp, pointed instrument will cut or scrape easily enough through the black ink. Perhaps the most readily obtainable tools are the scratchknife and the so-called "sgraffito" knives (Fig. 4). In appearance the scratchknife resembles a short, angular pen point, fits into a pen holder and is easy to use. The sgraffito knives are scraping or cutting steel points, which are also somewhat like pen points and fit into pen holders. These come with variously shaped cutting points and are particularly recommended for children's use since they are easily replaced and are not too sharp.

Most art supply and many hardware stores carry sets of cutting knives (Fig. 5). These are quite satisfactory for use and are available with sets of blades in graduated sizes which are interchangeable and fit into the end of a straight, metal handle. The smaller blades are best for cutting thin lines, while the broader ones are well adapted to scraping out larger areas of white. They also may be used to cut up the board itself.

Many art supply stores carry the small "frisquet" knife (Fig. 6), so called because it is customarily used for cutting frisquet paper. It has a sharp point and a small, slightly curved blade which can prove very useful.

Another tool that presents interesting possibilities is the glass etcher (Fig. 7). Designed for etching on photo negatives, it is obtainable in most good art supply stores. Because it came to my attention only recently, I have not as yet worked with it very extensively, but it seems to show definite promise.

Since the elementary approach to making a thin-line drawing on scratchboard requires merely cutting a thin line through the black ink to reveal the white chalk beneath, a sharp point of any kind is all that is actually necessary. But, when we come to more advanced drawings

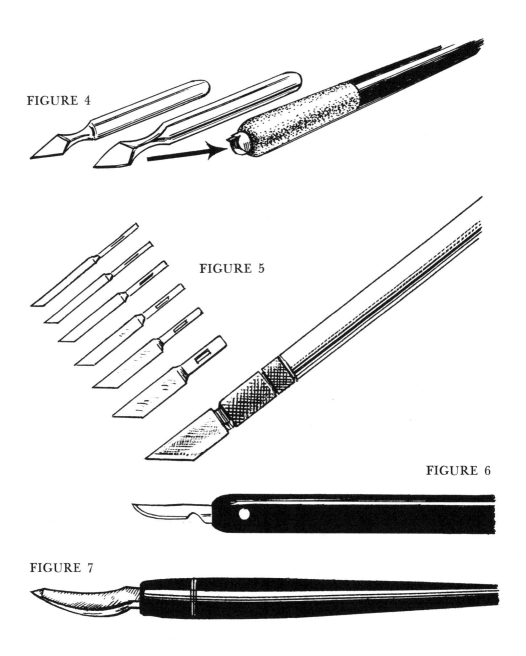

FIGURE 4

FIGURE 5

FIGURE 6

FIGURE 7

involving varieties of line and the handling of the picture in terms of masses or tone values, neither the knife-shaped tool nor the simple, pointed tool seems to be fully satisfactory.

The tool which gives the needed flexibility of line and at the same time permits the artist to achieve almost any effect he might wish to

14

FIGURE 8

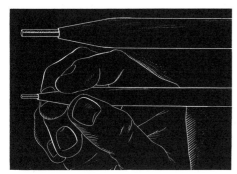

This pictures the pencil-like, steel engraving tool as purchased. It should be held naturally.

FIGURE 9

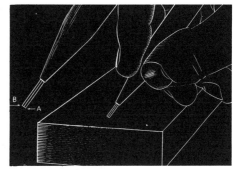

When sharpening, the position of the tool upon the oilstone is highly important.

FIGURE 10

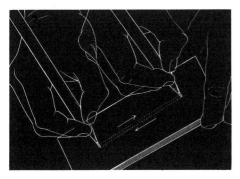

By a carefully controlled back-and-forth motion, the tool is gradually brought to a point.

FIGURE 11

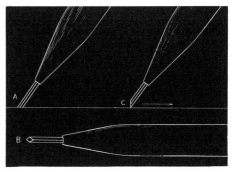

The resultant diamond-shaped point, B, is held as at C for most types of cutting.

accomplish is shown in Figs. 8-12. The only trouble is that I don't know where one can buy it. It is used primarily by engravers, and I presume that it may be found where engraver's supplies are sold, also perhaps in some art supply stores.

This tool consists of a square steel rod encased in a wooden handle and resembles a rather thick pencil. It is available in various thicknesses of the steel rod. I have found that the one having a rod about one-sixteenth inch square is the most satisfactory, and I use it for all my cutting. The square steel rod must be sharpened on an angle before using. This is done simply by rubbing it back and forth on a small, flat oil stone that has a little oil on it.

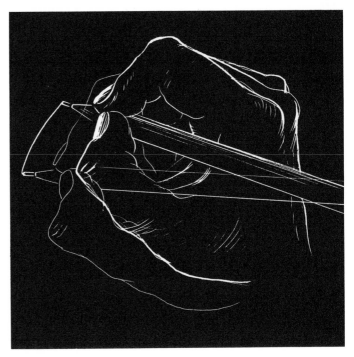

FIGURE 12

One of the points, or corners, is placed on the stone directly under its opposite corner and at about a 45 degree angle. Then it is rubbed rapidly back and forth until the bottom becomes flat, as shown in Fig. 11-*A*. Turn the tool over, and you will see that the bottom now has a wedge or diamond shape (Fig. 11-*B*). A view of the tool in the proper position for cutting is shown in Fig. 11-*C*. By varying its position and pressure, the tool is capable of a wide variety of strokes (Fig. 12). In cutting a scratchboard drawing, always draw a tool toward you, never away.

It has occurred to me that a very good possibility lies in some of the instruments a dentist uses. My dentist tells me that he frequently has worn or broken tools for which he himself has no further use. With an oil stone and a little ingenuity these could be converted into perfect scratchboard tools, perhaps even a variety for different cutting purposes. And, of course, these dental instruments are made of the finest steel and the handles are very practical.

16

APPLYING THE BLACK INK
TO THE BOARD

THE TYPE OF PICTURE TO BE DONE largely will dictate the area to be inked and its position on the board. Tone or mass drawings will always fall into either the category of a regular shape, such as the square, rectangle, circle, etc., or an irregular (vignette) shape. First, outline the area with pen and black ink, then fill it in using a sable watercolor brush (about No. 3) and black waterproof ink. The ink should be applied thinly and quickly to prevent the formation of bubbles or globules, which will crack when they dry.

I prefer the method of covering, with a brush not too full of ink, an area about one and one-half inches each way. Keep your hand in position and use just the fingers for short, swift strokes as in Fig. 3. Then you may move your hand and add another area, until the space to be worked upon is covered. If it should not appear black enough, simply go over it again.

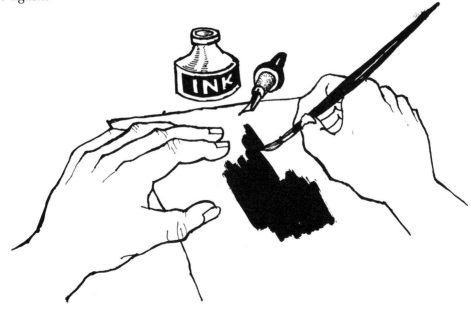

Chapter 4

CUTTING TECHNIQUES

IN SCRATCHBOARD, AS IN ALL OTHER MEDIUMS, the individual must find through practice the best way to express himself and to achieve the effects he desires. This is what makes it so difficult to attempt specific advice and instruction beyond the most elementary suggestions as to the use of the tools of the craft. For, just as with writing, it is possible to teach a person how to hold the pen and how to manipulate it, but in the end that person's writing will be his alone, completely individual.

However, there are certain elements in the mechanics or craft of cutting used to achieve certain effects that can well be pointed out to save the beginner much time and error. The correct combination of these effects will produce at least an adequate picture of almost any subject.

The cutting tool should be held much as one holds a pencil or pen, and the cutting should be done in much the same manner used to draw with either pencil or pen, perhaps adding a little more pressure at times. Invariably the line will be best cut by drawing the tool toward you while turning the drawing from time to time to make this easy. I also find that making strokes of not more than two inches, using just the fingers and keeping the hand in one position, gives the best control, somewhat as shown in Fig. 13.

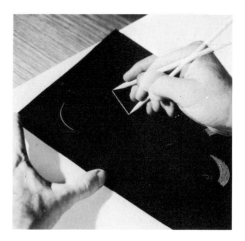

18

FIGURE 13

FIGURE 14

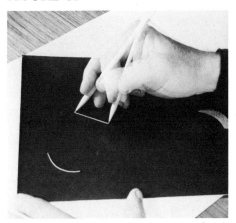

With fingers extended, draw the tool in a straight line toward the butt of the hand. Several parallel lines may be made with accuracy by keeping the hand in this same position. To lengthen the lines, move the hand to the next proper position and resume the process from the end of each line.

FIGURE 15

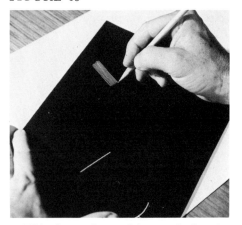

This shows the position of the hand at the finish of several parallel lines executed with the hand held in one fixed spot. By extending the fingers and moving the hand to the correct position, another similar group of lines may be added.

FIGURE 16

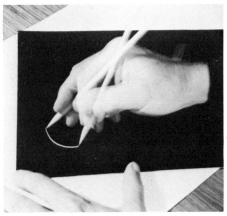

For a curved line, the fingers are first extended and the hand is then rotated from right to left with a slight retraction of the fingers toward the end, using the ball of the hand as a pivot. Several parallel lines may be made in this manner, but they will tend to get shorter as they approach the pivot.

FIGURE 17

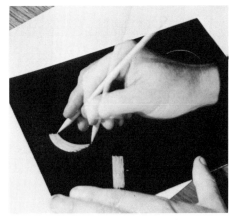

This shows the position of the hand at the completion of several curved, parallel lines. If the opposite curve is wanted, turn the drawing until the desired curve accommodates itself to the easy position of the hand.

FIGURE 18

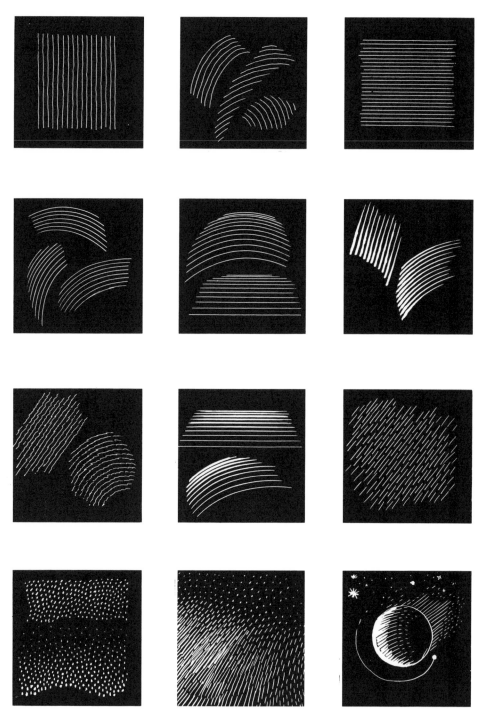

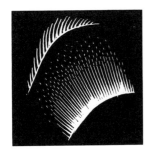 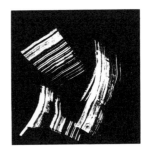

Of course, the kind of tool used will dictate the resultant type of line, but for our purpose I shall refer to the sharp-pointed, wedge-shaped tool shown in Figs. 8-12. With such a tool you can make quite as many different kinds of lines as with a pen (Figs. 14-17). And with combinations of these lines, varying the width and crossing them, you can produce multiple values, shadings, and textures.

Fig. 18 shows about all the kinds of lines of which I can think. Perhaps you can add some more. However, I believe that all my scratchboard drawings are made with these, or with combinations or variations of these.

Here, too, consider cross-hatching. Cross-hatching is the term for crossing lines over one another, as indicated in Fig. 19. It is best used to achieve texture, but I feel that even for this purpose its use should be consciously limited. However, it is often used as a means of correction. For example, when an area that has been cut turns out to be too light or too dark, the easiest way to change it is to cross it with white or black lines. But the best way, of course, is to cut correctly in the first place.

FIGURE 19

Chapter 5

THE APPROACH

WHEN A PERSON DECIDES TO MAKE A PICTURE, it seems certain that he must have a reason, and that reason is bound to affect his thinking and general approach.

Broadly speaking, there are two major reasons for doing a picture and, while they sometimes overlap or intermingle, I will use them as a division of approach as they affect technique.

The division lies between pictures done for fun or love and those done for commercial use. The first type I shall call the unplanned picture and the second, the planned. Of course, it is true that some pictures done for fun are planned, and the opposite is true of some commercial drawings.

These two divisions of art are frequently referred to in print or in conversation as (1) "Fine Art" and (2) "Applied Art"; however, I shall refer to them as No. 1 and No. 2. The terms are used for intent and definition and are not to be taken too literally because certainly all pictures executed with the intent of No. 1 do not turn out to be "Fine Art," while, paradoxically, time has proved many works executed in the category of No. 2 turn out to be "Fine Art."

Approach No. 2 is done for the purpose of pleasing others or of being commercially useful to them, and in most cases the artist is well-paid for the work. This puts the artist under the obligation of knowing beforehand almost exactly what the finished picture or design is going to look like and usually of letting his client see a preliminary sketch. These facts, together with the customary exactness with which a commercial drawing must be rendered, suggest the necessity of preparation or planning. This is particularly true in the scratchboard medium, since it does not lend itself easily to changes.

So, the No. 2 type of picture certainly should be planned. Obviously there is more to be said about the preparation and technique of

this type of picture than of the unplanned or spontaneous kind. This will be dealt with later.

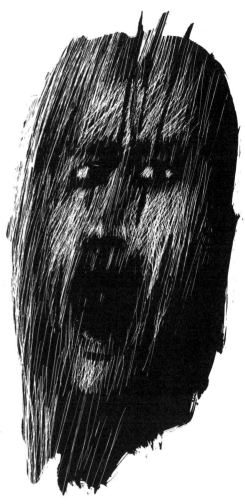

This exciting "unplanned" drawing was made entirely from the imagination.

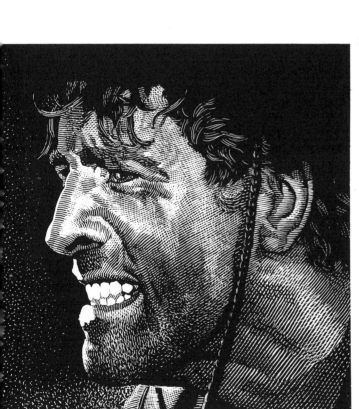

This fine example of a "planned" picture is the work of Walter Kumme.

THE UNPLANNED PICTURE

I CHOOSE TO CALL THIS APPROACH "FREE ART," and it is, just as the name implies, free of rules or obligations. It is done to please oneself, and its main purpose should be to act as an emotional outlet — to express something seen or felt by the artist. It is usually spontaneous and therefore unplanned, and this very quality adds to its interest, charm, and freshness.

Even though there are no rules, I would not dig into the rather inflexible surface of scratchboard without some idea of a picture in mind. It need not be entirely clear; in fact it can be almost in the subconscious, but a general theme should exist. Once the picture has been started, you can feel your way almost like a traveler with a lantern on a dark path at night, and each light cut or scraped from the black on scratchboard is a revelation and surprise even to oneself and suggests further exploration.

Pictures may be done directly on scratchboard, without preparation, with a subject to interpret in front of you.

. At home, I did such a subject, a chair with our cat on it, *directly on the scratchboard* (Fig. 20). This picture brings out another point, which is that it is not always necessary to blacken the whole surface of the white board. It depends upon the subject. In this case, the one object, the chair with its interesting shape, was my theme and I blackened it in with a brush directly from my subject. Then, the pattern or design of the wicker work was brought out by cutting within the black silhouette.

As for cutting technique, I would say that all the things mentioned on this subject later in relation to the planned picture may be applied to the unplanned picture. However, because there are no limitations on "free art," such as reproduction, the sky is the limit. In fact, the essence of such a picture is experiment. Add the black any way you want with anything you want: brush, shaggy brush, pen, stick of wood, or even a

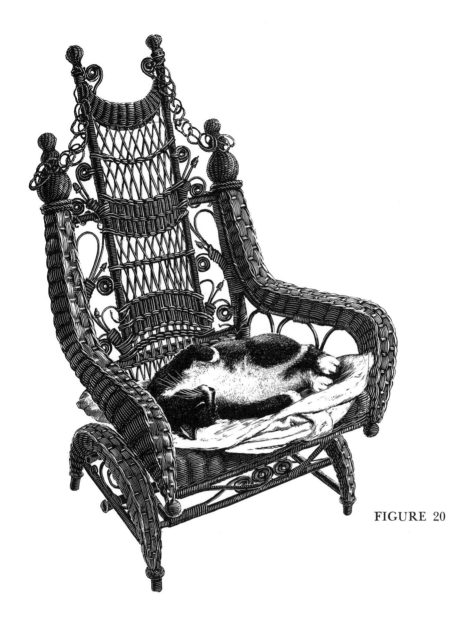

FIGURE 20

sponge, which can lend an interesting effect. And effects are important!
As you have no color with which to play, it is texture and pattern that
take its place and lend excitement and interest. With any tool you wish
(even your fingernail, if it will give the effect you want), scrape or cut
the black off in any way you desire, even if a gray tone is left in places
because all the black has not been removed. Whites may be cut over
this. Black may be added over cut whites, and then cut again. Add and
subtract. Excitement and interest through effects such as texture and

25

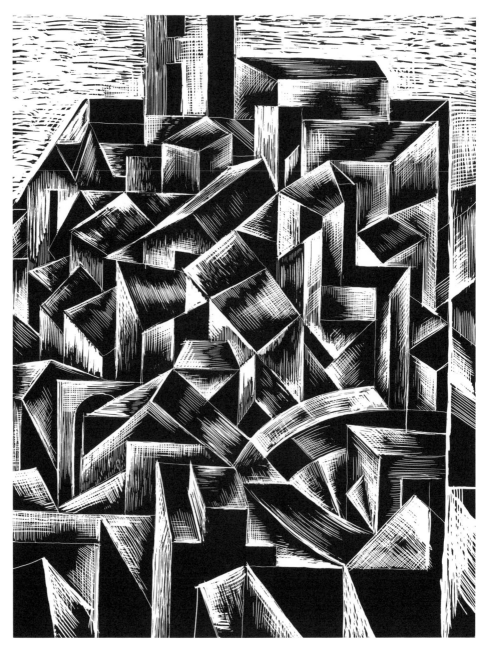

FIGURE 21

pattern, which are, of course, important in representational art, become even more important in abstract art, where there is little else upon which to fall back. In this category, experiment and ingenuity become

26

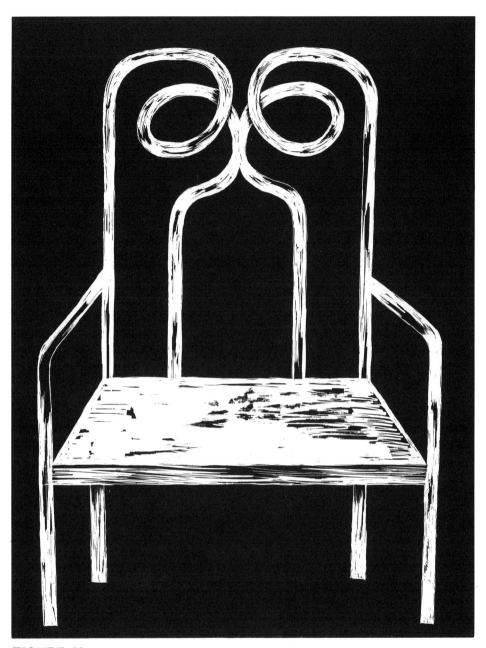

FIGURE 22

increasingly important as, for example, in Fig. 21, where texture and black and white pattern create a strong feeling of architectural volume. Fig. 22 shows another such experiment, a chair done from imagination

directly on scratchboard by Larry Lewis, an artist friend who had never before made a scratchboard drawing.

Scratchboard seems to hold a tremendous fascination for children. The New Canaan (Connecticut) Country School has been holding classes over the past several years in this medium for children from seven to fifteen years of age. Mr. Andrews, their instructor, tells me that they jumped into it with more confidence and excitement than they do with other black and white mediums. Here are two examples from the school (Figs. 23 and 24).

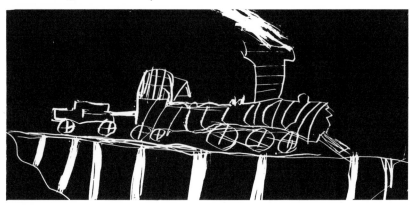

FIGURE 23

The locomotive shown in Fig. 23 was done from memory by a boy about eight years old. It is interesting to see the difference in approach to the same subject. While the one shown in Fig. 24 is more accurate, that shown in Fig. 23 has far more verve and "go." Their "memory" must have been based upon *pictures* of locomotives, since neither could ever have seen any of these antique types, except in museums.

One practical use of the unplanned picture is as a personal Christmas card. There is a great satisfaction in making your own cards, and certainly it seems more personal. A line cut can be made of your drawing and printed on cards of your choice. Any printer can do it from your drawing, and the total cost can be less than commercial cards you buy. The delightful Christmas card shown in Fig. 25 was made by an illustrator friend of mine. The beautifully stylized engine contrasts interestingly with the children's rendition of a similar subject.

If you are the cautious type and wish to make a very exact rendering, it would be wise to use the technique explained in the following chapter.

28

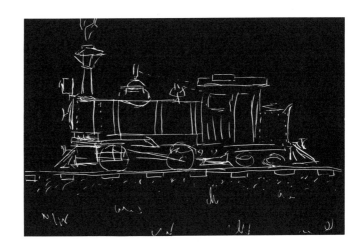

FIGURE 24

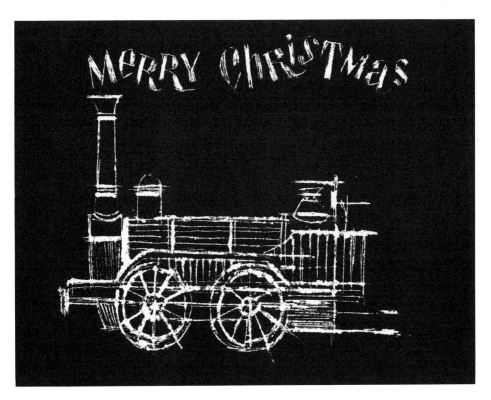

FIGURE 25

Chapter **7**

THE PLANNED PICTURE

MOST WORKERS IN SCRATCHBOARD WILL, I BELIEVE, find the planned approach the most satisfactory in its results. This fact is due primarily to the very nature of the scratchboard medium, its demand for precision, and the difficulty of making any subsequent changes. These considerations become even more compelling when a commercial drawing is to be made, for in such cases you are almost always given a specific subject to render and your rendition of it must be accurate. Under such conditions, scratchboard is a medium demanding craftsmanship.

For the purpose of illustration I have taken one simple, well-known object to show how it is applied to the board and how it dictates, before the cutting begins, the area and shape to be painted in black India ink on the white, chalk-surfaced scratchboard. The subject I have chosen is a photograph of a beautiful, old, wrought iron weather vane, the work of an artist and a craftsman (Fig. 26).

Before taking up the techniques of rendering a planned drawing of this subject on scratchboard, I will show an unplanned drawing of the same subject. I choose my wife as the creator, and the result was copied directly from the photograph to the scratchboard. To the best of her knowledge this was a first attempt since childhood at drawing of any kind. The result, while perhaps interesting and amusing, is certainly not a highly accurate rendering (Fig. 27).

Using the photograph of the chicken weather vane shown in Fig. 26 as our theme to be rendered as a planned scratchboard drawing, we will show the steps preparatory to cutting.

First you will need an accurate outline of the subject on your scratchboard as a guide to fill in with black ink. To achieve this, you must trace its outline on tracing paper laid over the preliminary picture in this way:

Place the photograph of the chicken on your drawing board and, to keep it in place, fasten it at the top with a piece of scotch tape (Fig. 28).

30

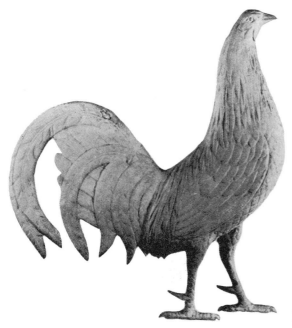

FIGURE 26

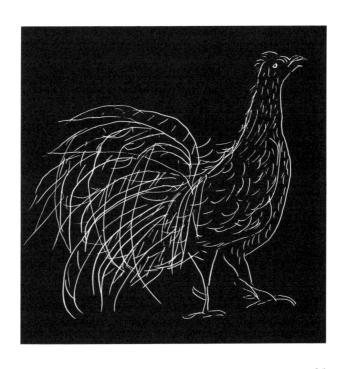

FIGURE 27

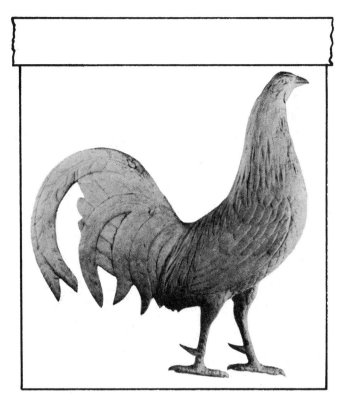

FIGURE 28

Over this lay your piece of tracing paper, a little larger than the subject photo, and fasten it in the same way with scotch tape. Then, with a medium grade pencil, about HB, carefully trace the outline of the subject, which you can see through the tracing paper. You now have an accurate outline of the subject, which can be transferred to the scratchboard for inking as a silhouette.

Now, while your tracing paper is still in place, trace lines inside the shape, such as an outline of the feathers and the placing of the eye, which will later serve as guide lines for cutting. Your result will look like Fig. 29.

Do not worry about copying, because when you have finally rendered the subject in scratchboard it is yours alone, and no other interpretation could possibly be the same.

After completing the tracing, lift it (including the tape) from the copy material, turn it over and apply a coating of red chalk on the back surface of the tracing. This is to enable you to make a "carbon copy" of your drawing right on the scratchboard itself.

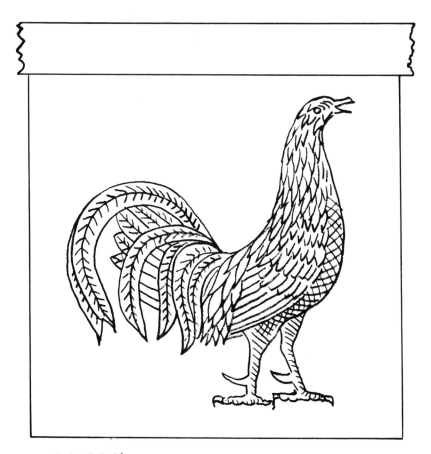

FIGURE 29

Chapter 8

TRANSFERRING
TO SCRATCHBOARD

TO RECREATE YOUR "CARBON COPY" ON THE SCRATCHBOARD, take your tracing and place it, face up, on the chalk-surface of a piece of scratchboard. Now, press down on the strip of scotch tape, thus fastening your tracing in place. Then, with a very hard, sharp pencil trace the outside contour of the chicken. When you have finished tracing, without removing the scotch tape, lift the bottom of the tracing and fold it back using the tape as a hinge.

You will now find a thin, dull red line on the white scratchboard where the pressure of your tracing pencil has transferred some of the red chalk from the back of your original tracing of the chicken. This is your guide to the next step — inking in. With a pen, go over this thin red line with black India ink. Whatever red may still show can be easily erased with a soft, kneaded rubber eraser. Then, with brush and ink, fill in the outline with solid black as shown in Fig. 30, where you also see the tracing folded back showing the red chalk.

You now have a black silhouette of your chicken on the white surface of the scratchboard. This establishes the black area accurately and, as you have a preliminary line drawing which fits its boundaries, it also allows you to trace off onto the black such additional inside detail lines as you may wish — the outline of feathers, the eye, etc., as a guide for your final cutting. Fig. 31 shows how you may do this by folding your tracing back once again over the silhouette and tracing the desired details, which appear on the black area as dull red guide lines to aid you in your cutting. Figs. 32 and 33 show the simple, but effective, scratchboard rendering one can make just by following the chalked guide lines.

This shows the red chalk applied to the back of your tracing.

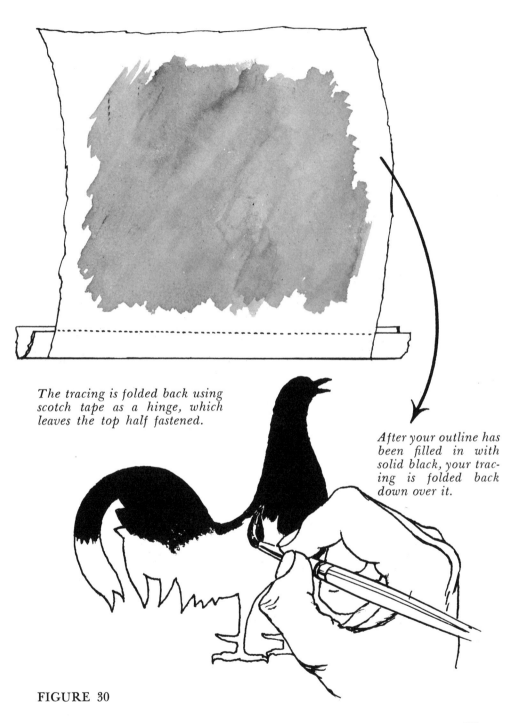

The tracing is folded back using scotch tape as a hinge, which leaves the top half fastened.

After your outline has been filled in with solid black, your tracing is folded back down over it.

FIGURE 30

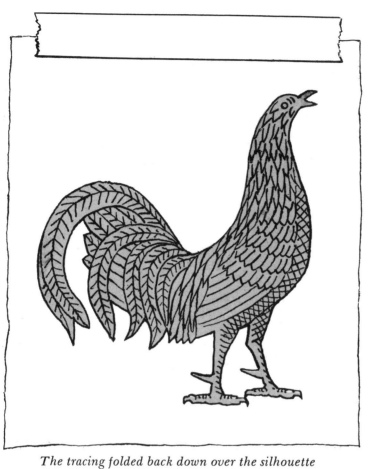

FIGURE 31

The tracing folded back down over the silhouette

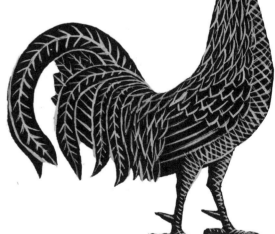

FIGURE 32

*The black ink shape on the board with
guide lines in dull red to guide cutting*

36

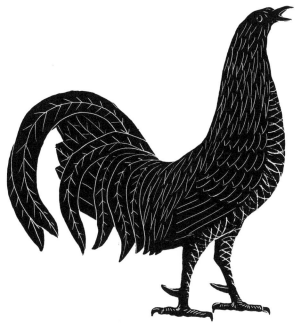

FIGURE 33

This shows about the simplest way of rendering this subject and could well be done by a child. It consists simply of cutting evenly along the guide lines.

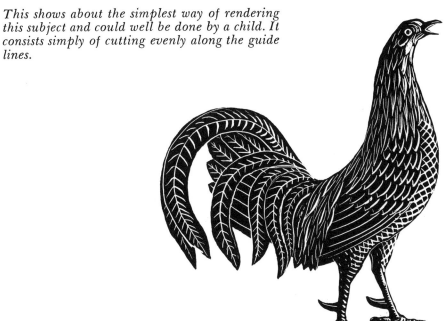

FIGURE 34

A rendering is presented here which seems more sophisticated because there is a greater feeling for light and shade, form, and decorative quality in the cutting line.

Chapter 9

DEVELOPMENT AND
VARIATIONS OF A THEME

OF COURSE, SCRATCHBOARD IS THE EXACT OPPOSITE of such mediums as pen and ink, pencil, and crayon, which are usually rendered in black on a white surface. This fact is emphasized here because when you are working on scratchboard you must think in terms of bringing light from dark, not just of making a line drawing. It also affects the choice of subject or, rather, the conception of the subject. It particularly affects the selection of a picture from which to work in making a scratchboard rendering. For successful translation to the scratchboard, your picture should contain much more dark than light and, preferably, have high contrast; that is, do not have gray tone all over, but rather sharp blacks and whites (Fig. 34). For example, I would not even think of attempting to render on scratchboard a white chicken against a white background.

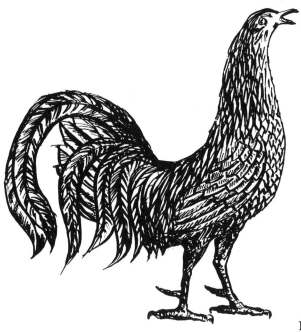

FIGURE 35

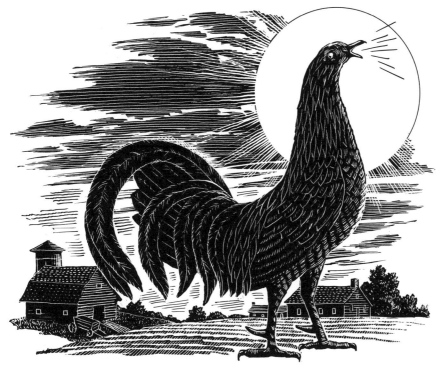

FIGURE 36

Here is a pen and ink rendering (Fig. 35). It is done, of course, in black ink on a white background and looks like a black on white picture, which it is. While a somewhat similar effect is achieved in the scratchboard drawing in Fig. 34, is will be seen that in Fig. 34 the whites are fewer and much more precise and clean.

I would like to show that there are many possibilities for developing or adding to any simple subject or object. Such development may be planned as part of the original conception or it may be added later, even after the original subject has been put on the board and cut. In any case, a drawing for the new material should be made, traced onto the board, and the extra black added, precisely as was done in getting the original subject onto the board (Fig. 30). Here is one way in which we could develop our original chicken subject by adding a background to it, while still keeping the picture in a vignette, or irregular shape (Fig. 36).

In Fig. 37 you will find a different approach to the development of the chicken theme. An indoor setting is given here, which calls for an all-over, or regular, black-inked background (with the exception of the window, which was left as uninked white board). These two examples suggest only a few of the almost infinite number of ways in which a subject may be developed.

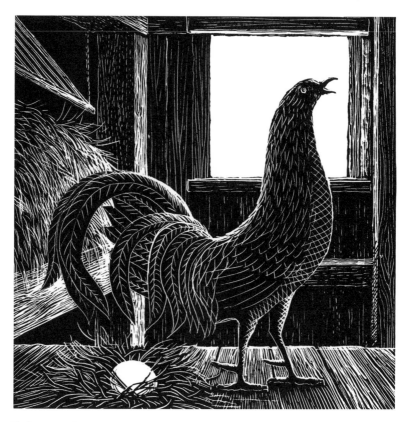

FIGURE 37

While a scratchboard drawing is essentially composed of white lines against a black background, there are occasions when it may prove simpler and more satisfactory to add a few black lines with a pen and India ink to a white area rather than to attempt to cut all around them. Thus, consider once again our subject, the chicken. In Fig. 37 it is

shown in the barn, with its head silhouetted against the white of the window. If we now desire to develop the picture further by showing a lacy outline of bare trees against the morning sky, it will undoubtedly be better to put this in with pen and ink, since there is so much more white than black (Fig. 38).

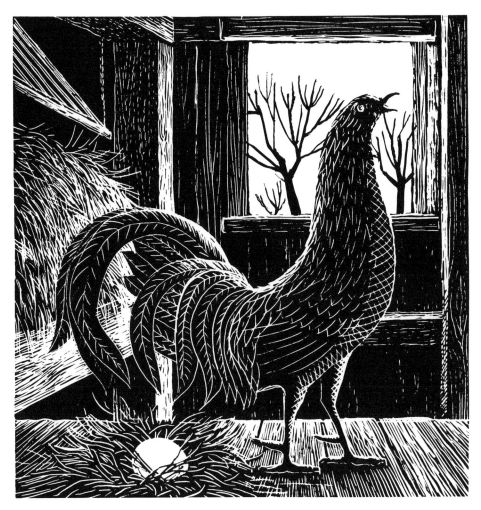

FIGURE 38

TONE VALUES

WE HAVE SPOKEN OF SCRATCHBOARD AS BEING A LINE MEDIUM, and so it is. Pen and ink is also. But there is one fundamental difference. With pen and ink you are engaged in adding black to white — black ink lines on white paper. With scratchboard you are cutting white from black by cutting the black-inked surface away from its underlying white chalk.

In either case it is the resultant mixture of black and white that creates what we sense as tone value when the eye blends light with dark. If your lines are close together and evenly distributed between black and white, you will have a middle-gray tone half way between black and white. Half of the area will be made up of black lines and half of white lines. It makes no difference what manner or technique you use in cutting an inked area of scratchboard; it is the amount cut that determines the value.

Tone values, considered by themselves, are pretty uninteresting, as can be seen in the three spheres in Fig. 39. It is by putting tone values in their proper relation to one another that we make a picture satisfying to the eye. This might be compared to music. It is not one note but the correct combination of notes that makes music. And just as one wrong note will create what we call a "discord" in music, so one wrong value will create a "discord" in a picture. By wrong value we mean a

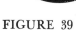
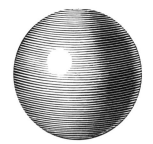
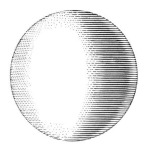

FIGURE 39

tone that is either too dark or too light to relate properly to the other tones in the picture. Here it is interesting to note that the same term, "tone," is applied both to a musical note and to a value in a picture. We speak of people as having a good ear for musical harmony. Likewise, a person may have a good eye for tone values.

Tone values range in scale from black to white. Black is the darkest value, white the lightest. Between these two lie many shades or values of gray, depending upon how much white is taken from black, or black added to white (Fig. 40).

FIGURE 40

SCALE OF VALUES

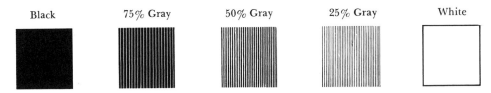

By varying the amount of black and white, one can obtain the illusion of any desired tone of gray. You should practice making tones ranging all the way from black to white. Copy the above scale; then try others of similar values using dots, irregular lines, etc.

Let us try to make this mixing of black and white to form grays of different values more explicit by using liquids as an example, such as black ink and milk. Fig. 41 shows a pitcher containing 75 per cent black ink with 25 per cent white, or milk, on top. We will pour this into a similar pitcher so that the two liquids are evenly mixed.

The tone of the overall mass of the liquid has now become an even 75 per cent gray through the mixing of the black and the white. The same effect will be seen in the 75 per cent gray panel in Fig. 40, but in this case it has been achieved on the scratchboard by cutting 25 per cent of the white from the panel of black ink.

43

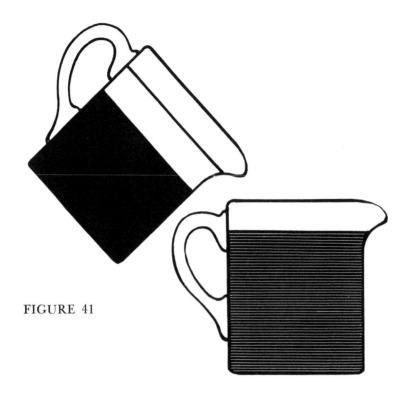

FIGURE 41

Now, by the same process, we will mix 50 per cent milk with 50 per cent ink (Fig. 42). The result is an even 50 per cent gray, as seen in the line or cutting process in Fig. 40.

Following the same method, mixing 75 per cent white with 25 per cent black gives us a 25 per cent gray tone (Fig. 43). By the cutting method, of course, this is achieved by removing 75 per cent from the solid black.

It should be repeated here that in a case wherein an area of a picture is as light in tone value as 25 per cent or less, it is better to leave this area white and to put in black lines rather than to cut away such a large amount of white.

And remember that subjects most appropriate for cutting in scratchboard lie in the range from 50 per cent to pure black. Leaving some areas of the picture pure black is most effective and desirable; the gray tones may then be keyed in relation to the black. Small areas left pure white usually add to the picture's effectiveness. It is quite surprising what attractive results can be obtained in many cases with a small amount of cutting. Fig. 44 is an example.

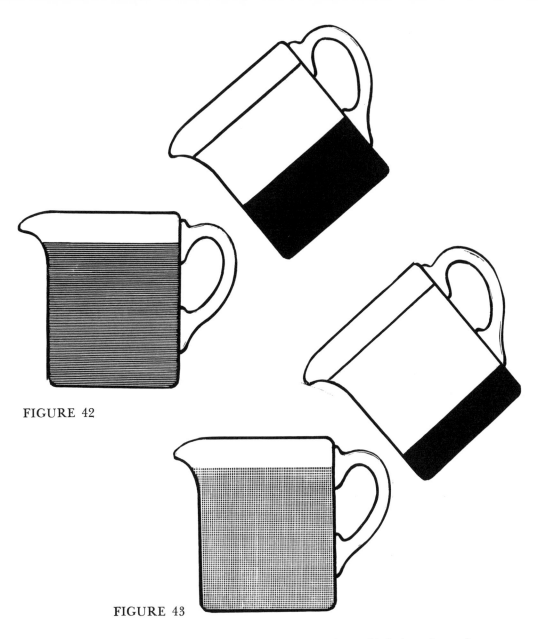

FIGURE 42

FIGURE 43

The early lady motorist (Fig. 45) is in flat front lighting, but placing her against a black background and using a variety of textures lends interest. The costume itself — the scarf, the bow, the goggles, even the hands, the horn, and the wheel — tends to break up the whole into interesting shapes and textures. Notice the variety in cutting techniques: the feeling of softness in the scarf and bow against the sharp, bright cutting of the shinier surfaces of the goggles, horn, and gloves. Solid black and white have been used to good effect with comparatively little cutting.

45

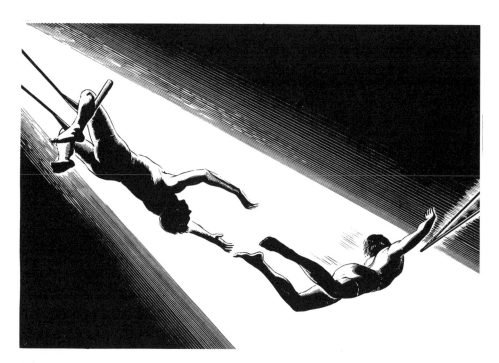

FIGURE 44

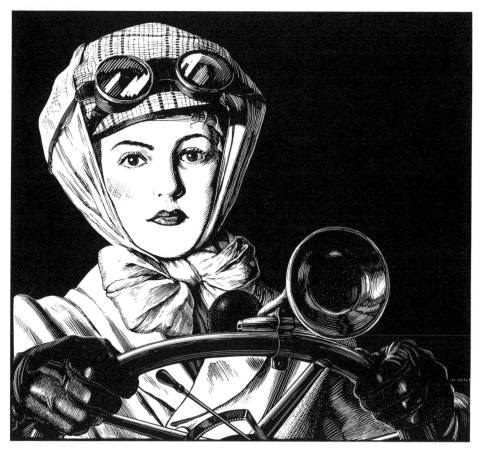

FIGURE 45

SHADING OR BLENDING

SO FAR, WE HAVE CONSIDERED A VALUE OR TONE as if it were uniform over a given area. This would be the case only if the area were a flat surface, and not always then. We have also spoken of line drawing on scratchboard and of tone drawing. Of course these two can be, and usually are, combined in producing a single chalkboard drawing. The so-called "modern" school of art appears to have concentrated upon the abstract or flat type of expression. It does not happen to satisfy me, but I think that all that has been said up to this point would allow you to express such an approach in scratchboard, should you so desire.

My own approach to making a scratchboard drawing would be difficult to explain in a few words. I certainly would not say that it was wholly realistic. But it would surely include what I call form, because everything I see about me has three dimensions or volume.

Form is revealed by light, and one bright light on an object often seems to tell more about it than a dozen lights from different angles. To see how magnificently form can be revealed by simple lighting, consider Rembrandt. We all know that the outline drawing of an object, or its silhouette, shows us only its shape. We must observe the way the light hits an object on the side toward us to get a clue as to its form. Turn now to Fig. 46. Here is an outline drawing of an object, a cone. This outline, as seen from our viewpoint, only partially establishes its identity. It might just as well be a pyramid or, indeed, merely a triangular plane surface.

Now, throw a light on it from the left side (Fig. 47). It is clearly not a triangular plane surface, but it still might be a pyramid because of the straight, hard edge of the shadow and its uniform tone.

Fig. 48 shows us what happens when the uniform tone of the shadow is properly blended or shaded. Shading allows us to blend one tone or value into another. This gradual change in tone gives the appearance of roundness. The tone will be the lightest where the sur-

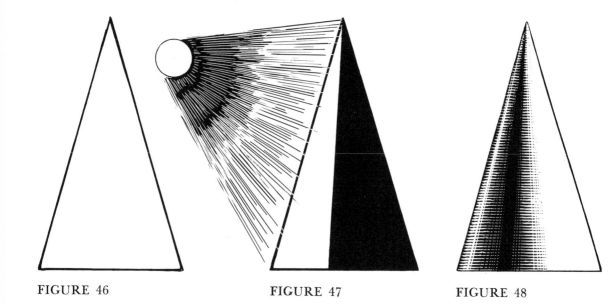

FIGURE 46 FIGURE 47 FIGURE 48

face of the object is nearest to the light, and it will darken gradually as it curves away from the light. In practice it will be found that some gradation of tone within the shadow area also helps create a feeling of form or roundness. Note, too, that the tone has been lightened at the extreme right perimeter. This has been done because there is almost always a certain amount of what is called reflected light, which is light reflected upon the subject from other objects or background on that side.

There are many possible ways of shading or blending to obtain a feeling of form or roundness. Four commonly used systems are illustrated.

For example, the shading in Fig. 49 is done with straight lines across the cone, widening the white as the source of light is approached. The darkest part is left black, but a little of this black is removed from the right side to reveal the reflected light.

In Fig. 50 the shading is accomplished through the use of straight lines running up and down the cone from its base to its apex. Of course, the whites should be cut wider on the side toward the source of light. I feel that the method of shading shown in Fig. 49 is superior, since the lines follow the direction of the form. This is a matter which will be developed further.

48

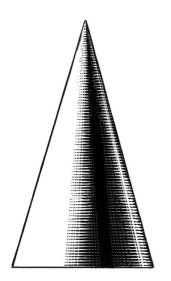

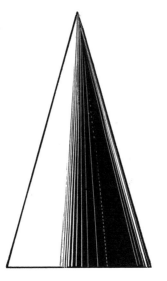

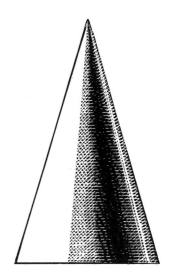

FIGURE 49 FIGURE 50 FIGURE 51

Yet another method is shown in Fig. 51. Here, straight lines are first cut all the way across the black to give a 50 per cent gray value. Then we add and subtract by crosshatching. On the light side we crosshatch by cutting additional white lines to lighten the tone, while in the depth of the shadow we add crosshatched lines in India ink to darken it.

Fig. 52 shows still another technique, which we may call the dot and dash method of blending. Start by cutting short dashes of white into the black or shaded area. Reduce the dashes to dots, letting these in turn fade into black. For the reflected light on the right side, resume with small white dots away from the reflected light and gradually increase to small dashes. A few small black dots may be added at the left to fade into the light.

The form or shape of an object is identified not only by the rendering of light and shade on it but also by the direction of the cutting lines. Lines should always be cut to follow the contour of the form. Until now, for purposes of simplification, we have shown our cone at eye level. Now we raise it slightly above eye level, as in Figs. 53 and 54. The fact that the cone is above eye level is clearly evidenced by the ellipse at the bottom, which also immediately reveals its round form. Any shading

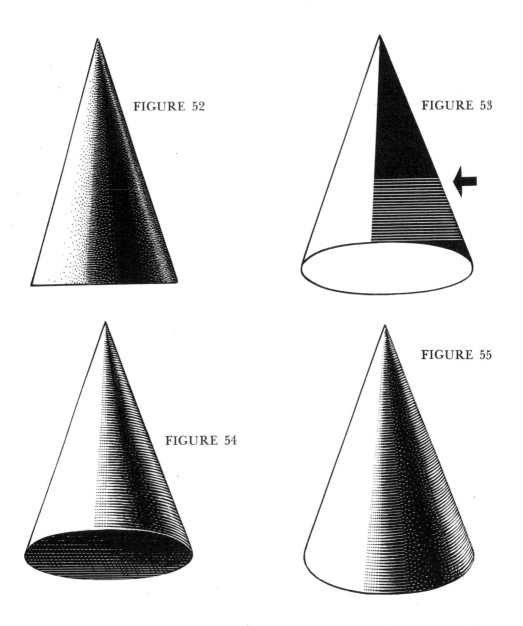

FIGURE 52

FIGURE 53

FIGURE 54

FIGURE 55

lines on the curved surface should be cut to follow the contour line established by the ellipse at the bottom.

Fig. 53 gives a striking example of the wrong way to cut — with straight lines that do not follow the form.

Contrast this with Fig. 54, which shows the right way to cut lines to obtain a better tone value or shading. The lines should always follow the form of the surface which they represent, for by doing so they in-

FIGURE 56

This excellent example is a wood engraving, also a black and white line medium. Note the use of the principles of technique mentioned in this book, such as the curving of the lines to reveal form and contour in the arms and legs.

crease the feeling of form and shape. Note particularly that straight lines have been used in cutting the bottom of the cone. This is correct and is the best possible way of showing that the bottom is flat.

Now, lower the cone slightly below eye level as shown in Fig. 55. Note how the shading lines curve up from the center of the ellipse, instead of down as in Fig. 54, for here they once again follow the contour line established by the form. In each case the shading has been done by the method shown in Fig. 49, since I feel that this is the best way to treat a smooth surface. At eye level the lines would be straight across. Of course, the shading lines above eye level should curve up; below eye level they should curve down.

Chapter 12

PATTERN OR DESIGN

WHEN SOME, OR ALL, OF THE SURFACES OF THE OBJECT to be rendered are smooth in texture and of an even or solid color or tone, a difficult problem is presented. For, one seems limited to very regular cuttings, usually either straight or curved lines or dots, and it is hard to create much interest. I would never willingly choose such a subject, but in professional work this is frequently encountered.

Fig. 57 is an example of such a subject. Although it has strongly contrasting tone values, there is little pattern or design in the dark areas to give an indication of the type of cutting needed. The shadow areas of the arm and hands had to be treated in an almost even, dotted technique.

Fortunately, most subjects have pattern or design. In nature, either in the formation, texture, or coloring of the subject, I think this is almost always the case. Manufactured objects also have pattern or design, either for the same reasons as natural objects, or applied. For example, let us take three very simple objects, similar in shape, and render them with the same lighting.

Fig. 58 shows a billiard ball — hard, smooth, regular in color and shape — and, consequently, rather monotonous. Note how it is rendered with even, curved lines, which diminish from white into black.

In Fig. 59 the object to be rendered is a squash tennis ball. The webbing on the ball immediately gives us a motif and suggests, in turn, the manner in which the cutting should be done. For, since the cutting through black into white is the technique with which we are working, the way in which light hits any raised part and the shadows are thrown gives us our clue as to how to cut in order to allow identification of the object.

In Fig. 60 the stem and the formation around it help us to to identify this form as an apple. In most kinds of apples there is also a pattern or motif formed by changes in color. This, in turn, gives us our direction of line and, together with changes of value within the areas of light

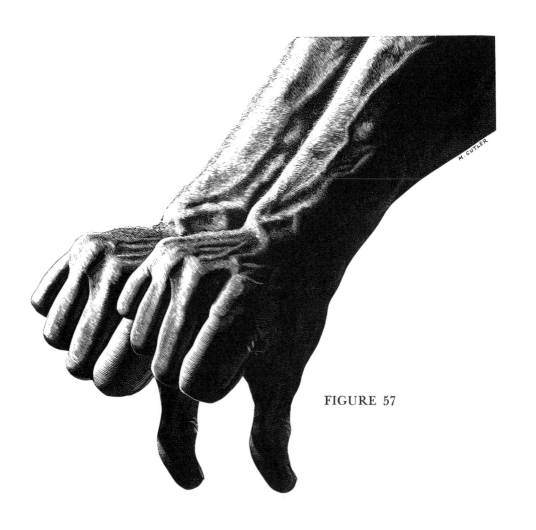

FIGURE 57

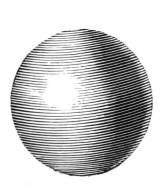

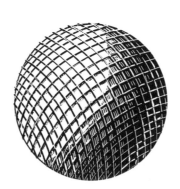

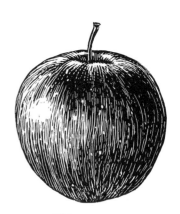

FIGURE 58 FIGURE 59 FIGURE 60

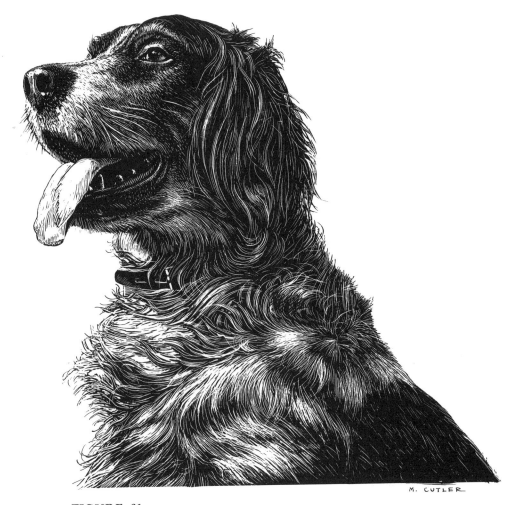

FIGURE 61

and shade, helps our drawing to say "apple."

Fig. 61 shows an excellent example of texture dictating the method of cutting. The hair is the obvious motif. Its form or direction has been followed, which, combined with the light hitting it from the left, gives it conviction and form.

55

Chapter **13**

LIGHT: THE CLUE TO CUTTING

AS SCRATCHBOARD TECHNIQUE involves cutting through black to reveal white, it may well be compared to throwing a light upon an object to establish its identity through its form, texture, and pattern. Here again we are dealing with tone drawings, not line drawings. The way the lights hits our subject is the best guide to cutting. In general, it may be said that the part of the object which is nearest the source of light will be the lightest in tone; and this tone will progressively darken the farther away it is from the light. This, of course, applies only to the object as a whole, because projections, irregularities, or raised portions will catch the light, often making it necessary to cut a pure white on such configurations, even though they may lie in a general shadow area. A simple example of this will be seen in Fig. 62. The old iron pot is greasy and therefore shiny. Light hitting it from the left brings out the pitted design and, with the crack, gives us the motif for cutting. The simple silhouette and the skill of our cutting identify the subject and make it interesting.

A photograph with simple lighting will give you all the clues you need as to where and how to cut. Practically all my work is done from photographs. If I can't find one that I want, I take one myself. Here is a fine example (Fig. 63). The photograph has been purposely lighted in order to show just where and how to cut. Light hitting the hair shows the direction and the kind of line. The outline, with a few guide lines for the shapes of the lighting, was traced as described on pages 30 and 32. Applying the drawing to the board and cutting it took just three hours (Fig. 64).

When a precise, straight or curved line or series of lines is required, as in rendering an object with a smooth surface and an exact outline (such as a glass), I do not hesitate to employ mechanical aids. For an absolutely straight line, I use a ruler; and to produce a uniform, smooth curve I rule with a French curve. A set of these instruments comes in

56

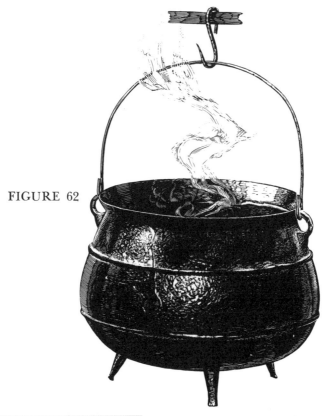

FIGURE 62

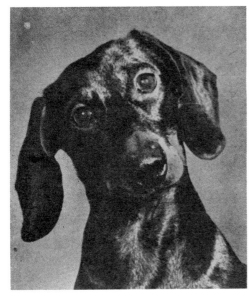

FIGURE 63

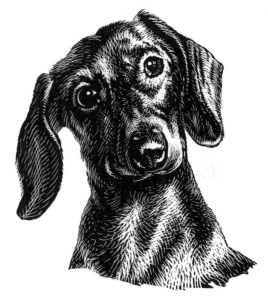

FIGURE 64

57

FIGURE 65

FIGURE 66

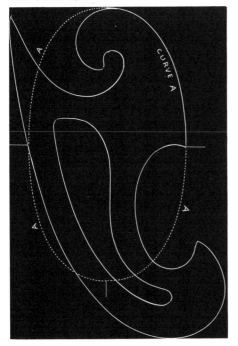

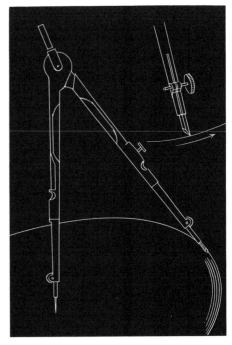

A French curve has many uses. Here, by shifting to permit the ruling of curve A four times, it serves as an aid for constructing an oval.

In this compass, a metal point has been substituted for the customary graphite. This permits cutting arcs or complete circumferences into the scratchboard.

very handy and gives almost any line or curve desired. Even an exact oval may be made by ruling the same curve four times, once for each of its four quarters, as in Fig. 65. For those who don't mind the extra investment, sets of plastic ellipses are sometimes available in stores catering to draftsmen.

It would obviously be difficult to cut a perfect circle freehand on scratchboard. To solve this problem, I have made for myself a scratchboard compass which works flawlessly. I simply extract a short section of the square steel rod from a scratchboard tool, sharpen it as demonstrated in Fig. 9, and substitute it in a pen compass for the pen itself. With the point adjusted to the proper position to cut an arc or circumference, this compass is manipulated like any other (Fig. 66).

It is very unlikely that anyone would choose to do a subject such as this for fun (Fig. 67). And you are right, I didn't. I did it because I

FIGURE 67

was well paid. It is shown here as an example of a subject where obviously mechanical means (such as the ruler and the French curve) are necessary for accuracy. Don't try to do such a subject freehand.

SUMMARY

START WITH SIMPLE SUBJECTS of a generally dark mass, particularly with those where the vignette or shape readily helps to identify them. For practice, treat a subject very simply. Use a single line to outline the mass and the main forms lying within the mass. This old locomotive will serve as an example (Fig. 68). Note that the line has been cut whiter, or wider, where the light (which is from the left and overhead) hits raised portions. A few, very simple shading lines have been added to the round parts. Since this subject is made of iron, it is all of one smooth texture, and so it is treated with the same type of line throughout. The dog in Fig. 61 was all hair and was treated accordingly with a hairy line over the whole surface.

Let us start with some simple heads. For the purpose of shading, think of the head as a ball with nose, ears and hair added. As you practice, gradually advance to subjects that, while still simple and with simple lighting, have more variety in tone and texture. Lines and dots properly used will give the effect and tone value of almost any texture. The examples in Fig. 69 show how correctly chosen lines and dots can give the effect of hair, fur, skin, and cloth.

FIGURE 68

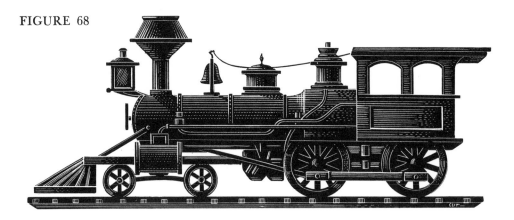

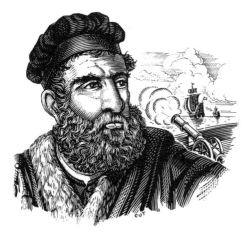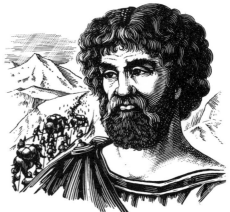

FIGURE 69

Chapter 15

EXAMPLES

THE DRAWINGS ON THE FOLLOWING PAGES were done as commercial jobs and therefore are rather advanced, but each is based directly on the methods and fundamentals that I have already explained. The rest is just practice and experience.

It is hoped that, together with their explanatory captions, they may help in your study and development in the rewarding medium of scratchboard.

The head of John Wayne (Fig. 70) is a rather advanced example and is, furthermore, a combination of scratchboard and pen and ink. In order to obtain the very smooth, realistic effect desired, certain already cut parts were crossed with black pen lines. In turn, in order to correct or shade an area, one may cut across in another direction with white lines. This means that one can work on scratchboard in both directions, almost as in painting, and get very realistic results. This is not a typical scratchboard drawing and is shown here merely to indicate what can be done to obtain a realistic effect. It certainly should not be attempted by the beginner. The original drawing was about twice this size.

No one could mistake Fig. 71 for anything but an ear of corn on a stalk. Again, the shape you black-in (as is evident here) will identify the object to a large extent. This applies to all vignettes.

The corn is treated as a whole object and the individual grains are rounded, as explained in Fig. 48. The leaves and the stalk are cut with thin, not too smooth lines where the light hits, which would be on the veins and on the contour of the leaves. The corn silk on the end suggests its own cutting — just thin lines following the hair where the most light hits.

So far, we have spoken of scratchboard as a medium only and how it is prepared and cut. Let me emphasize here that, as with all mediums, it may be handled in many different ways, depending on the individual-

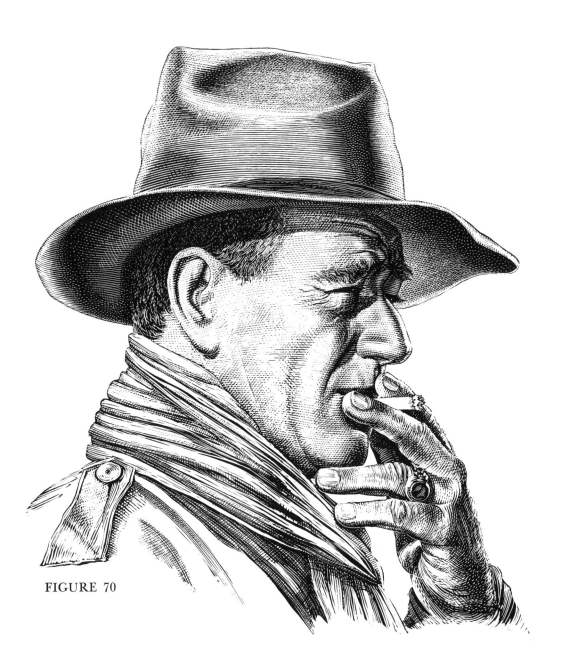

FIGURE 70

63

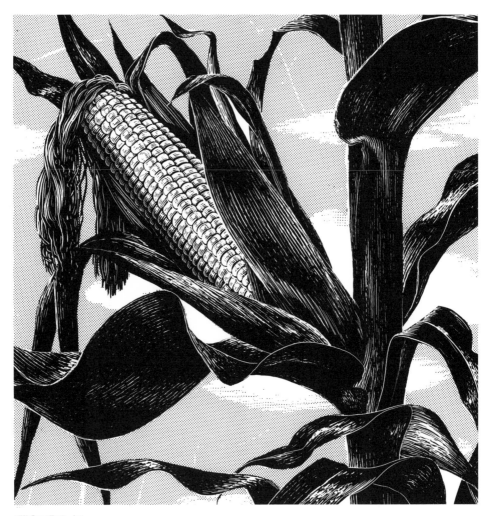

FIGURE 71

ity or approach of the artist. The examples of a planned picture shown
so far have been from what I would call the realistic approach. Fig. 72
suggests what I consider a decorative approach, that is, a picture not
directly copied from a photograph but more assembled and stylized.
For instance, notice how schematic the handling is of the horses and the
architectural details. It also is usually a simplification of a realistic view.

To emphasize the early French feeling of the Chateau Frontenac,
a rather crude type of old French woodcut was simulated (Fig. 73). If
desired, this drawing would allow a great deal more reduction in size.

64

The rendering in Fig. 74 was made for a motion picture advertisement in which likenesses were necessary. The lighting is flat, following that of the still photo provided. This is not the most interesting lighting for scratchboard, but it does allow large areas of white to be left on the faces (only the shadow being blackened and cut), thereby simplifying the drawing. Cutting the girl's hair was the most fun.

In a silhouetted (vignetted) subject, such as Fig. 75, there is no point in inking beyond the boundary line. This finished rendering is typical of the woodcut type of technique commonly employed by the scratchboard artist.

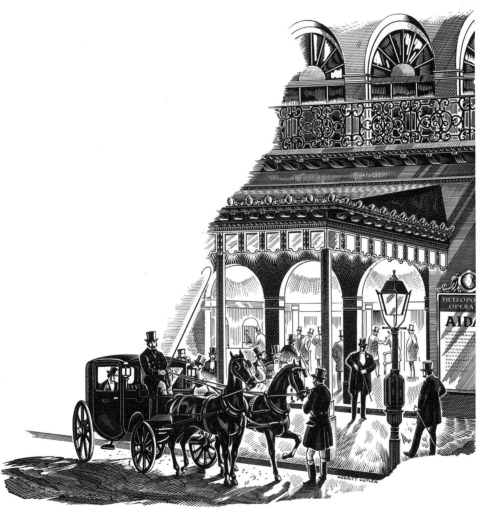

FIGURE 72

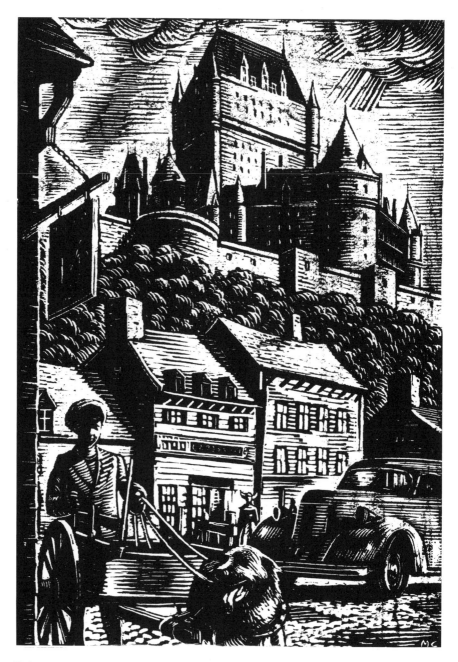

FIGURE 73

66

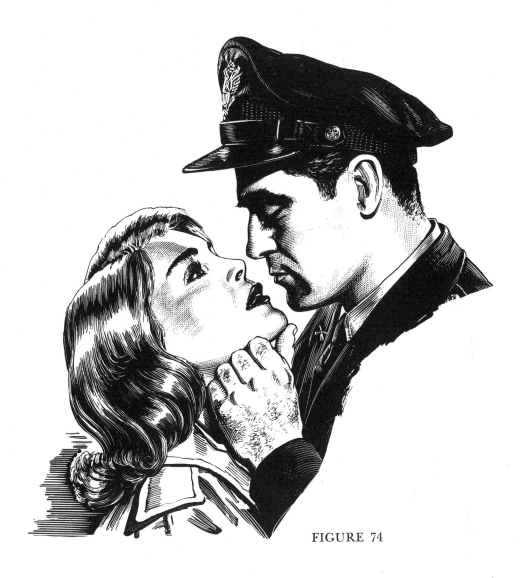

FIGURE 74

Fig. 76 shows how a scratchboard drawing of silverware, shown finished in Fig. 77, was inked on the board preparatory to cutting. In the finished drawing you can see clearly where and how the cutting was done. The drawing was made directly from the objects, as no time was allowed for taking a photograph.

Fig. 78 is the first stage in a scratchboard rendering, with the parts blacked-in preliminary to the finished drawing seen in Fig. 79. The full black lines at the bottom of the sky were inked in before any cutting was done. A rule was used in this case. Such planning saved much laborious cutting.

67

FIGURE 75

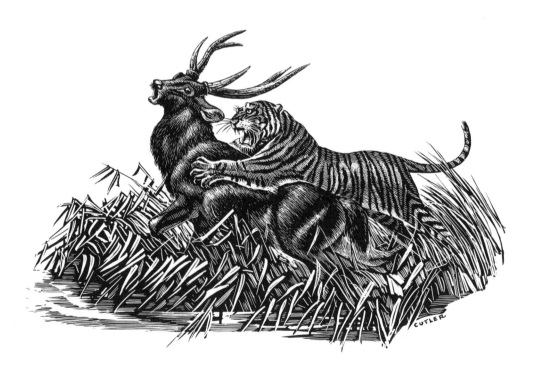

Fig. 79 is the final result of cutting the drawing above. Of course a ruler was used in cutting the even, parallel lines in the sky. The drawing was made from a photo.

In Fig. 80 longer lines are used for the long hair, shorter lines for the short. The horns are made almost entirely by stippling. The border was inked, leaving the large, curved spaces white. The rest was cut. It is easy to see the advantage of being able to cut the thin, white lines in a design of this nature. Incidentally, it is necessary to make only a half border of this kind.

A photographic negative is made of the drawing and then "flopped," as they say, by the engraver; that is, turned over and, with the unwanted parts of the drawing blocked out, matched to make the complete border, of which the engraver makes a plate.

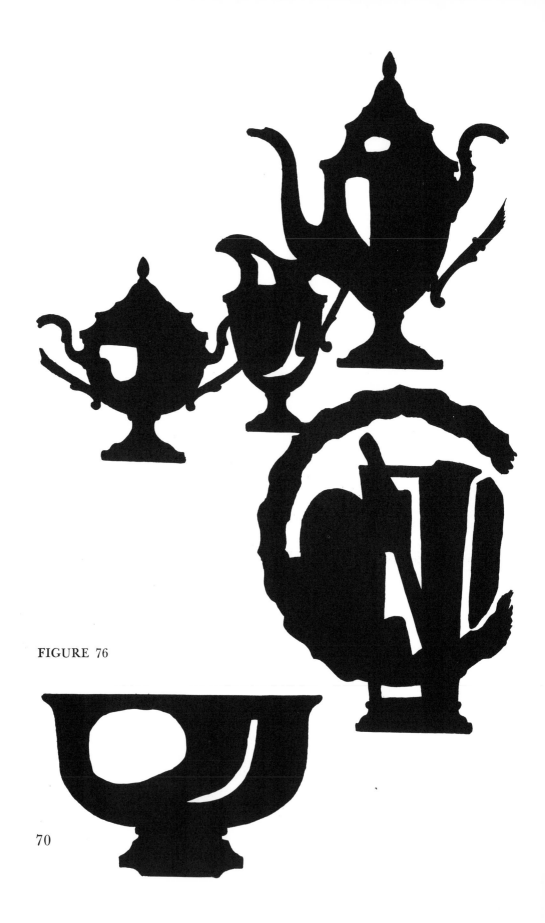

FIGURE 76

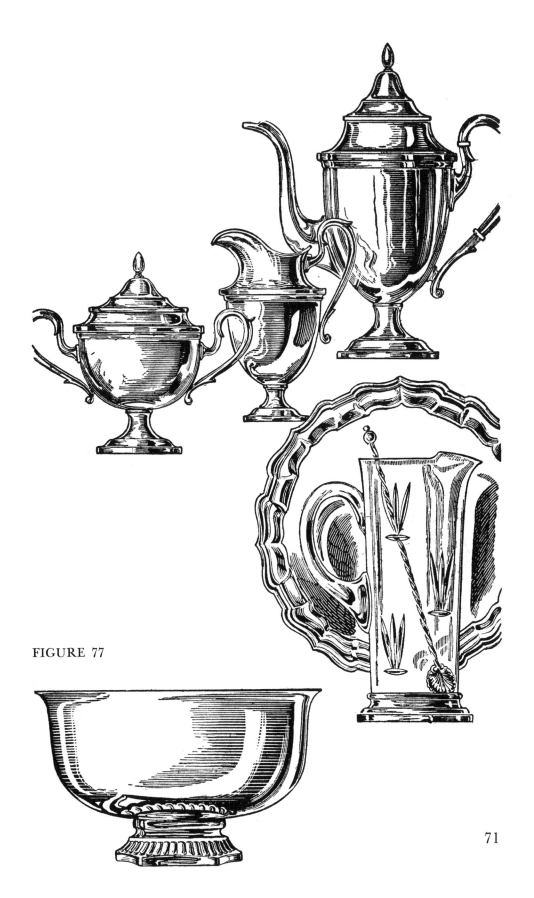

FIGURE 77

71

FIGURE 78

FIGURE 79

FIGURE 80

CONCLUSION

BASICALLY, THE SAME THINGS that make a good scratchboard drawing make a good drawing in any medium: the subject, the conception, the personal interpretation of the artist, and the technical mastery of the medium. In this book I have confined myself to trying to help in the last category.

I have always felt that art is almost impossible to teach, that the more it is an individual expression (your expression), the more it may be art. I have always been impressed by the belief that there are few facts or rules about art. If you doubt this, look at the work of any dozen great artists; they have all been innovators. Of course, one is bound to be influenced, and it is wise and desirable to know what has gone before. But to be able to select from or perhaps eliminate all these influences to enable yourself to start off on your own path is the difficult part.

Select from what you see in the way of technique that which seems suitable to yourself. Experiment with ways you have not yet seen, and eventually you may come up with your own technique.

While, of course, I frequently run into subjects having textures which, from experience, I have learned to treat in a certain way, I try to keep my mind free to consider every subject as a new experience, open to a new approach.

GALLERY OF SCRATCHBOARD DRAWINGS

Drawing by Micossi:
© 1959 The New Yorker Magazine, Inc.

The lively drawings on this page, created by Micossi for The New Yorker Magazine, achieve their decorative, semi-abstract design of bold black and white areas through a free use of the scratchboard techniques described in the chapter on The Unplanned Picture.

Drawing by Micossi:
© 1959 The New Yorker Magazine, Inc.

Opposite: *Guido and Lawrence Rosa, famous scratchboard artists, capture the dynamic character of mythological Pegasus through the use of emphatic, short strokes and strong value contrast. Note particularly how the incised white lines create a sense of volume by following the contours of the forms they describe.*

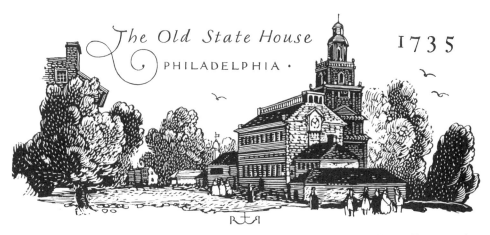

The Old State House
PHILADELPHIA ·
1735

In this fine scratchboard rendering the Rosa brothers develop the feeling for the historic dignity that the subject demands through a self-contained elaboration of pattern within form.

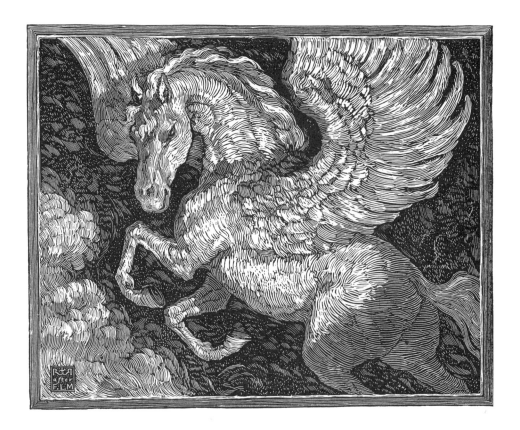

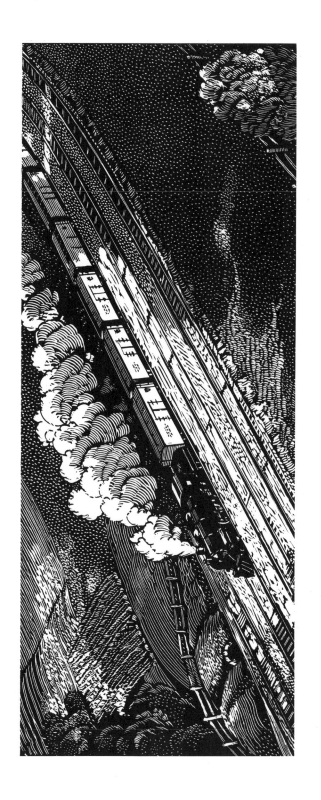

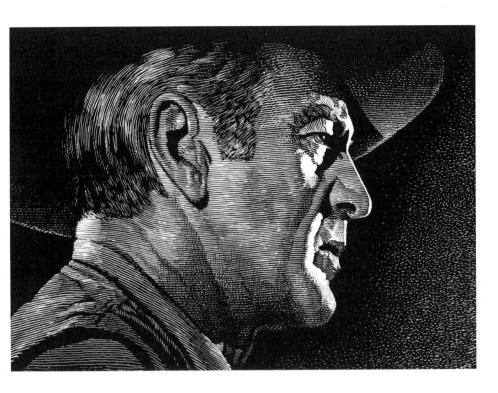

Walter Kumme is famous for his bold, realistic scratchboard portraits. By dramatically lighting the face, leaving some areas completely white, he forcefully focuses our attention and reveals both the character and likeness of Gary Cooper.

Opposite: *This detail from a commercial scratchboard rendering by the Rosa brothers combines many of the techniques used for creating the varied textural effects which are discussed in the text. Note the effectiveness of the broad handling of the main subject in centering interest and the treatment of the less important details for subordination.*

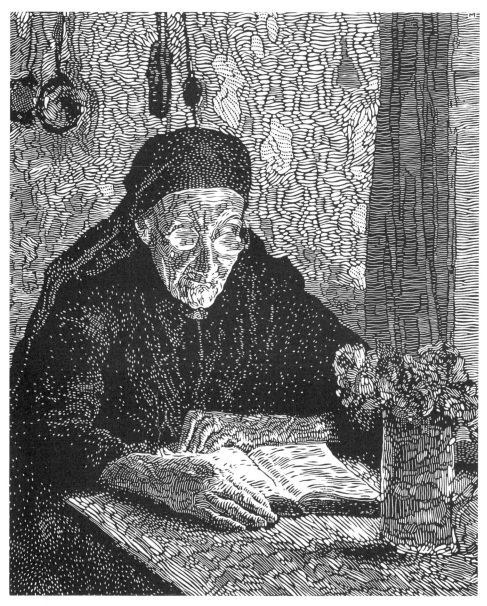

Ervine Metzl, one of the nation's outstanding illustrators and designers, demonstrated his early promise in this beautiful scratchboard drawing, which he made as a young artist of eighteen. The lightly textured black figure acts as a strong foil to the abstract, rich surface handling of the other objects.

80

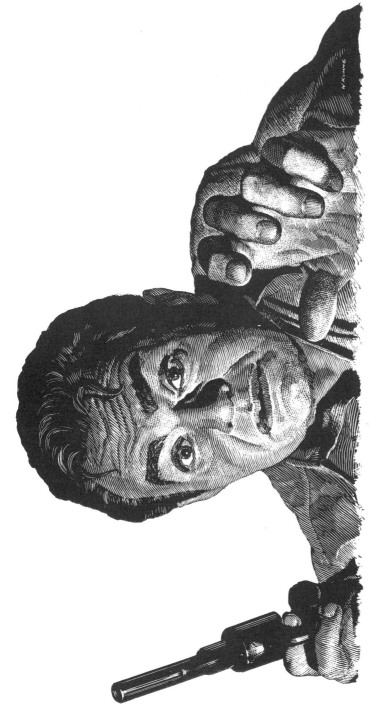

Notice how Walter Kumme adds to the effectiveness and accuracy of his scratchboard representation by the treatment of textures: the contrast of the mechanically drawn cold steel against the more subtle tone gradations and contours of flesh and cloth.

Guido and Lawrence Rosa have interestingly solved the problem of an over-abundance of detail and action by organizing the overall patterns into an abstract design of horizontal and vertical lines broken by diagonals.

Opposite: *Merritt Cutler has thrown a strong highlight on the gladiator, leaving areas of sharp contrast with almost no middle tones. The grayer and less distinct treatment of the gallery causes it to retreat effectively into the background.*

82

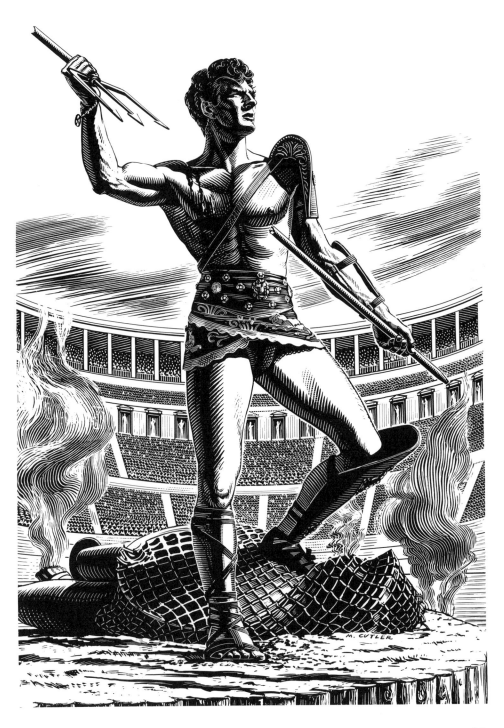

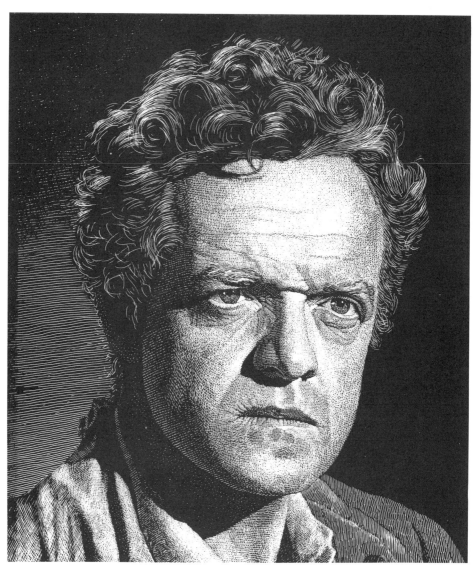

A variety of scratchboard techniques is used by Walter Kumme to capture the pensive character of actor Van Heflin. Note especially the combined use of stippling, crosshatching, and parallel lines to create the subtle gradation of tone and texture in the face.

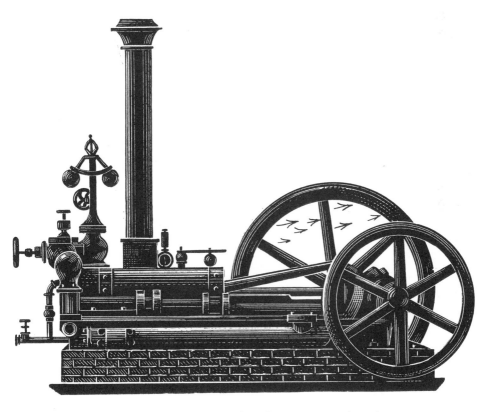

This engine, because of the lack of variety in texture and surface, presents no dominant possibility for interpretation. Mechanical techniques, as described in the text, lend it the clarity of mass inherent to machinery.

Again we see how effectively such materials as metal and ceramic can be captured in scratchboard. Careful planning of the lights and darks eliminates unnecessary cutting and provides a clear guide for accurate, interpretive rendering.

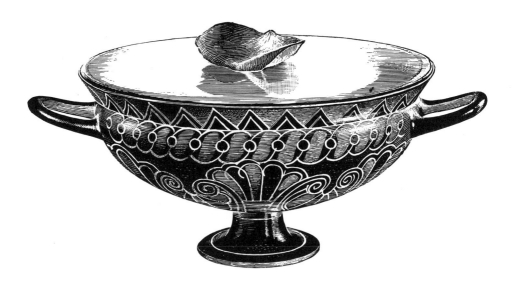

86

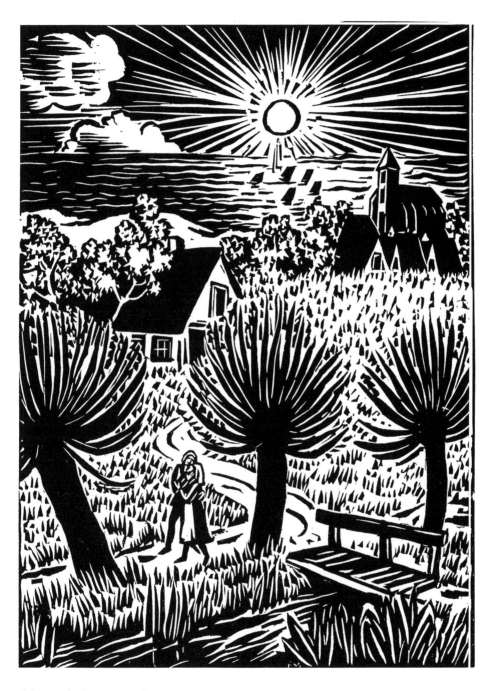

This fanciful woodcut by Masereel, with its strong light and dark patterns, could be reproduced as an equally effective scratchboard drawing (See page 66).

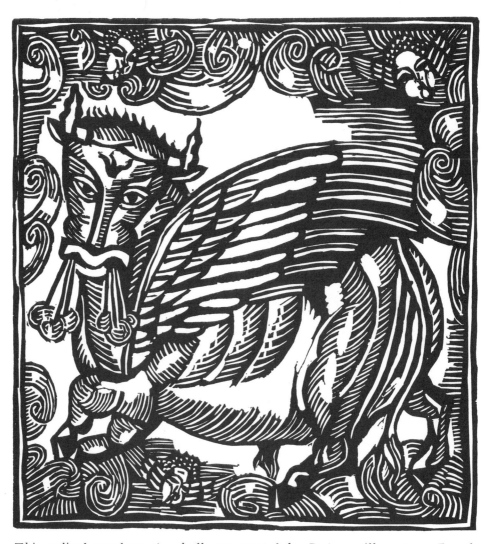

This stylized woodcut of a bull was created by Dufy to illustrate a French bestiary. The bold black and white design could be equally well realized by the scratchboard artist.